Nancy Atakan

Nancy Atakan **Passing On**

Edited by Nat Muller

KEHRƎR

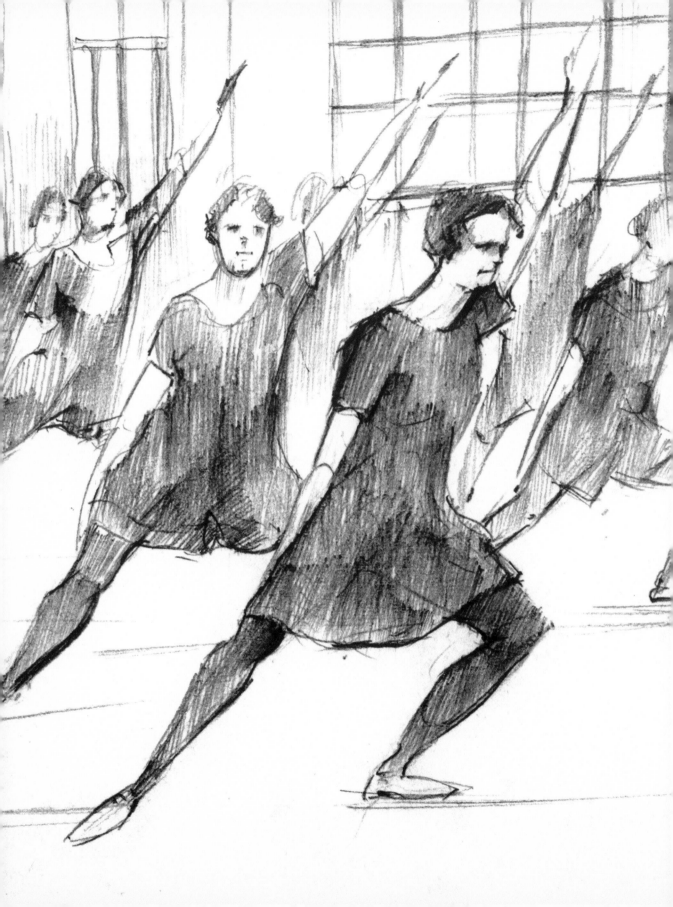

Contents

Foreword

Nancy was already an important artistic voice when I met her in the early 2000s and her solo show at Proje 4L Elgiz Museum, Istanbul in 2007 confirmed my appreciation of her work. I was particularly struck by the video installation *And*, which was created using a range of media including film, photography, drawing, stop-motion animation, collage, text, and sound. In the work, Nancy puts herself in the place of *'and'*; committing to function as *'and'*, she tries to connect two personal dream places.

Shortly afterwards, we began working together exclusively and since then have completed many powerful exhibitions together. Nancy's solo exhibitions at Pi Artworks Istanbul, include, *Mirror Mirror on the Wall* (2013), *How Do We Know We Are Not Imposters?* (2011), *From Here, 1970–2011* (2011), and *I Believe/I Do not Believe* (2009).

Nancy is one of the most articulate artists that I have ever had the pleasure of working with. She analyses the relationship between image and word while dealing with social, gender, and psychological issues, yet her work is also full of colour, humour and playfulness. In the past, she has completed a PhD in art history, written a thesis on conceptual art, written books and articles on numerous subjects, taught art, coordinated exhibitions, and made artworks, and it is because of this varied career that she is able to create works that are both theoretically rigorous and aesthetically strong. This book is a modest introduction to the artist.

I would like to thank Nancy Atakan for coming into my life and being a resident artist of Pi Artworks; Susan Hefuna for introducing us to the wonderful Kehrer publishing; Kehrer Publishing's Daniel Sommer; and Wendy Shaw and Merve Ünsal, who have contributed to the book. As always, I would like to pay my respects to the Pi Artworks team: Eda Derala, Tuğba Esen and Neil Jefferies. Lastly, I remain eternally grateful to Nat Muller for bringing everything together, and making this book possible for the artist's first solo show in London.

Yeşim Turanlı
Founder and director of Pi Artworks, Istanbul/London

Introduction
Nancy Atakan: Caretaking, Looking Back and Passing Things On

Nat Muller

For the past twenty years, Nancy Atakan has been a fixture of the Istanbul art scene. Ask any artist, curator or gallerist in Istanbul about Nancy and their look will start to soften. They will tell you how for some project or other her encouragement and advice had been indispensable and how for many years she has nurtured a younger generation of artists. In a world that has become increasingly competitive and individualistic, selfless 'caretakers' of Nancy Atakan's calibre are rare. As an artist engaged with social, feminist and historical issues, her caretaking is personal and often takes as its point of departure family histories and documents, as well as her own lived experience of being an American woman living and working in Turkey for the past 45 years. It is, in fact, an indelible part of her artistic practice: to share, exchange, collaborate, and support.

The publication *Passing On* focuses on the works in Nancy's œuvre that look specifically at the role of educated urban women in the period of transition between the demise of the Ottoman Empire and the emergence of the nascent Turkish Republic, founded in 1923 by Mustafa Kemal Atatürk. Atatürk's program of political, cultural and social reform was intended to modernise Turkey into a secular nation-state in which women would have equal civic and political rights. Much academic and political ink has been expended on praising and critiquing Kemalism, but suffice it to say that this period of change provides excellent material for considering issues of nation, nationalism, identity, gender politics and their respective constructs and conditioning. Moreover, this era captures what is at the core of Nancy's interests: the relation between occident and orient, the meaning of belonging, a change in the balance of power between the sexes, and different concepts of femininity. Nancy's take on history closely examines the inter-generational relations between women and what one generation learns and passes on—or should be passing on—to the next. She delves into unwritten and forgotten histories of the women who have inspired her, from her gym teacher Azade when she first came to Istanbul to her mother-in-law, who trained as an engineer. As such, Nancy is not only a chronicler of the past but also an excellent storyteller, uncovering narratives that have been shared between friends and family that also point to universal issues that are relevant for the present moment and for posterity.

As Turkey finds itself embroiled in an internal and external political quagmire, as President Recep Tayyip Erdoğan's conservative nationalist AKP minority government clamps down on freedom of expression and civic liberties, as Turkey's secularism is under fire and with the war in Syria having a spill-over effect, a look back at the past is warranted. Nancy does this modestly, through what she knows, has observed and has experienced. She asks us to reconsider what happens in the domestic sphere of the home, something that we might have dismissed or overlooked in an effort to counter the idea of the 'angel in the house', that docile 19th-century creature with no ambitions and desires of her own who is the perfect housewife and mother. But Nancy's women are no angels per se. They are strong and wilful. They are university-educated professionals who also fall in love, are caring mothers and occasionally bake cakes. The point is not to "have it all", in the women's magazines' version of it. Rather, she puts forward a feminist position that is inclusive, and that makes it OK for women to embrace all things girlie, if they so desire, but that this by no means undermines who they are and what they do. This is something young Turkish artist Merve Ünsal explores in depth in her interview with Nancy in this publication.

In the same interview, Nancy describes that it is through making art and studying art history that she tries to make sense of the world and her surroundings. This includes negotiating her own position as an American woman who has lived for most of her adult life in Turkey and who has had to adopt a new language, deal with novel customs and find new role models in order to make this new environment her own. Her method is very much one of learning-by-doing, wherein the process of conducting research, collecting documents and doing interviews, even if that information does not make it into the final work, is of utmost importance. We see this for example in the video *Lost Suitcase* (2011), presented as a series of video stills in the book. The atmospheric silent black and white film, made up of family photographs and documents, tells the story of Nancy's mother-in-law, who dated her future husband illicitly until the family finally approved. Both bride and groom travelled to Germany in the late 1930s to obtain their Master's in textile engineering, but their stay was cut short due to the outbreak of WWII and a hasty return to Istanbul followed. A suitcase was left behind. *Lost Suitcase* is a love story set during wartime, but also reflects on the double standards of the societal mores of the time. Women's emancipation, politically and in the work sphere, in the new Turkish Republic was heralded as one of Atatürk's markers of modernity, but the truth is that many women were still dependent on the whims of fathers, brothers and husbands, who determined their degree of independence. *Lost Suitcase* beautifully intertwines personal memory with a more universal account of loss and hope.

The fact that Nancy has chosen to narrate the video textually in first person singular connects her own biography with that of her mother-in-law. The female lineage is passed on, as it were.

First-person narration is also used in *My Name Is Azade (Freedom)* (2014), which makes up a central part of this publication. Not only do these pencil sketches with text provide a unique historical look into the life of a pioneering woman born in the early 19th century who dedicated her life to the therapeutic aspects of physical exercise, but it also articulates a zeitgeist and the prejudices women faced in Turkey vis-à-vis sports, physical exercise and modern dance. Azade, following in the footsteps of her influential father, who became the first inspector of physical education in Istanbul schools, could tread where many women could not go before. Yes, it is true that Azade came from a privileged background, but this does not overshadow the fact that there is an encouraging sense of achievement and agency running throughout the work. In other words, change is possible and with optimism in short supply in these dire times, Nancy's celebration of empowerment is refreshing.

In her essay for *Passing On*, scholar Wendy Shaw writes how Azade's father's ideals of a healthy spirit in a healthy body translated to the body politic of the new Turkish nation. 'In remembering Azade', she writes, 'we remember an era of hope, in which the actions of an individual held the promise of changing the practices of a nation, and we can only hope to live again in such a time of promise'. Like Azade, Nancy locates this promise in the body. The ideological values of a society are always played out over women's bodies. Indeed, as Shaw asks in her piece:

> What does this mean in modern Turkey, where the freedoms and choices of women continue to be marked and re-assessed based not simply on their opportunities for education and participation in the public sphere, but in the freedom and politics of their bodies, and implicitly of their sexuality, as marked in covering their hair? What does it mean as the entire project of national modernism that characterised the Middle East in the twentieth century is threatened through new forces of capitalism, Islam, and war?

The female body that takes centre stage in Nancy's videos is usually her own. In *My Name Is Azade (Freedom)*, it is the liberated, sportive and trailblazing body. But in works not included in this book, it can be the aging, imperfect or surgically enhanced body that tries to live up to a set of unattainable beauty ideals. As an art historian and former painter, Nancy is all too aware of how over

the centuries the female body has been depicted—idealised or loathed—mostly by male artists. After more than a century of feminist struggle and decades of strong feminist critique and women artists working conceptually and critically with the female body, in the 21st century the female body is still commoditised, consumed and conditioned. It is still too fat, too thin, too young, too leaky, too old, too homely, and too sexy. Nancy's work is not confrontational, nor does it provide any clear-cut answers to complex gender issues. It is more as if she were saying, "Look, this is what I see happening around me, this is what is happening to me". A keen observer, she collects, archives and documents these embodied experiences, and—of course—passes them on. This is well exemplified in the eponymous double-channel video *Passing On II* (2015). Here the screen alternates between Nancy and other women—from young girls to elderly ladies—all wearing black leotards and all individually executing a series of exercises that come originally from a VHS tape created by Azade in 1980 for her students. These exercise moves highlight the individuality of these women, yet seen together they also point to a shared and collective sensibility, which through this video has been made public. By repetitively performing Azade's moves in this looped video, a transmission of gestures occurs through time that symbolically incorporates all the wisdom and knowledge of the women who have performed these exercises in the past and relays it to the generations of women to come.

Though women are at the forefront of Nancy's practice, men are not left out. For example, in *My Name Is Azade (Freedom)*, it is Azade's father who is a role model for the young Azade. In works such as *What Something Is Depends on What It Is Not* (2002) and *Referencing and Silencing* (1998, 2000, 2011), issues of masculinity, class and ethnicity are complicated. In the former, a photograph of Nancy's dad, a private in the US army during WWII, is juxtaposed with a photograph of her Turkish father-in-law, an officer in the Turkish army. Due to the similarity in their postures and uniforms it is difficult to identify military rank. Moreover, who is the Turk and who is the American? Where is difference located in this image? This question is pushed even further in *Referencing and Silencing*, which shows a 1930s photograph of an elegant shorthaired Istanbul lady combined with a 1908 portrait painting of artist François Marius Granet. The resemblance between man and woman in terms of their features and clothing is striking. The portrait painting has been reproduced in sepia tint, lending it a distinct photographic feel. Gender, nationality, history, and conceptions of East and West are all muddled in this work, as are the disciplines of photography and painting. The strategic pairing of images in these two works challenges preconceived notions of identity. We have been provided with an artistic *trompe-l'œil* in which notions of affinity and difference are subtly yet playfully scrambled.

A touch of lightness permeates Nancy's œuvre, even though she addresses weighty issues. Politics are personalised, brought closer to home and to the realm of the everyday. For example, in *Father Knows Best* (2011), two silkscreen prints—one in English one in Turkish translation—depict a photo-roman based on stills from the popular American 1950s sitcom *Father Knows Best*. In the specific episode it is made clear to Betty, daughter of the house, that engineering is not a respected profession for girls. It is such an archaic, by now funnily clichéd, demonstration of patriarchy that we cannot but smile and shake our heads at it, knowing fully well that in some parts of the world this—and worse—is still the reality for girls and women. However, the punch line in this piece comes from the last slide, a black and white picture of a beaming Nancy in a wedding dress with the speech balloon 'I married an engineer'. Comic relief is a powerful tool and can unhinge and debunk ingrained societal stereotypes. These little interventions are testimony to her generosity of spirit and that she is not afraid of putting herself on the spot.

As a final editorial remark I'd like to note that it has been a privilege to spend time with Nancy for the production of this book. Sitting on her balcony in her beautiful apartment in Nişantaşı, where she has lived ever since coming to Turkey, and sipping copious cups of tea while nibbling on *simit*, we spoke about her artwork, what it means to be an American woman and artist living in Istanbul, and how the city and Turkey have changed in the turbulent decades (more than four!) since her arrival. As a reader you will notice that all contributors to the book refer amicably to the artist as 'Nancy'. This is not only because we feel friendship, familiarity and kinship with Nancy, but also because she has passed on something very personal and intimate to us by sharing her stories. This book *Passing On* is also my gift to Nancy for her 70th birthday. As much as Nancy honours the women who have influenced her, it is my wish that this modest publication honours her.

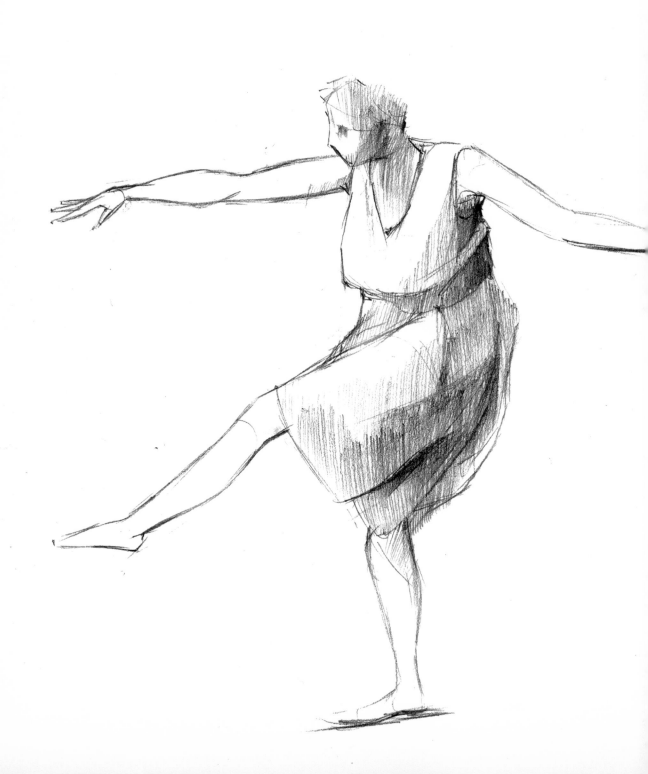

Gymnastics of Memory

Wendy M. K. Shaw

A young woman smiles at us coyly from a page, her head tilted forward, her mouth slightly open as though looking up and seeing a familiar face. A pencil drawing transcribes the image loosely, yet we know from the convention of the pose that the image was born in a photograph. This photograph would have been black and white, with a soft filter yet offering us the clear features of an individual. It might have had a dark backdrop, or perhaps simply shaded with tasteful decorations. Such a studio portrait was as typical for its era as the spit curl that lies on her forehead, springing from the fashionably daring feminist bob that signalled the liberation of the modern woman. We might not notice the bared shoulder in the foreground, shocking in its era in a way that it cannot be in our own. It is this shoulder, pressed to the front of the image, conveyed by a few lines in the drawing, which tells us in no uncertain terms that this figure constitutes a sign of modernity in the form of a woman.

Why transform a photograph into a drawing? What is gained in the loss of precision from one medium to the next? Here lies the gap between history and memory, between document and sediment, between tribute and translation. As viewers, we cannot know if the picture brings us face to face with the young woman that Nancy Atakan met in her old age, but this does not matter. In *My Name is Azade (Freedom)* (2014), we, like Nancy, are imagining an individual within a broader paradigm of womanhood in flux across history. This photograph has been kept from us; we cannot see it here, it is veiled by a drawing which transforms the image of an individual into an intimate relationship between the pencil of the artist and the sense of the person she tries to capture on the page. What we see is not simply a line drawing of a photograph, but rather a record of intimacy between a young American woman (Nancy) grappling with a culture in which she is at once at home and foreign, and a woman (Azade) who tried to change her world as part of a visionary moment of modernisation.

As this memory of the meeting of two generations and two cultures re-emerges through this work into our own world today, it meets with yet another generation that is increasingly faced with a politics of Islam that plays through the subjugation of women. To what extent have the physical struggles of early feminism, engaged by Azade, and those for self-determination, engaged also by Nancy, become part of the inheritance of women today, in Turkey as well as in the world? Whether exposed in advertising or veiled in modesty, the body of

woman remains a sign. This is all the more clear today, as the veil continues to determine a complex politics of religious identity in Turkey, in the Middle East and in Europe. In contrast to the freedom envisioned and embodied in movement for Azade, as long as a woman's body remains a sign outside of her actions, the vision of Azade's generation will not have come to fruition.

The late nineteenth to early twentieth century Ottoman Empire was a period of revolutionary vision and dynamic reform. The era is frequently remembered through the phrase "The Sick Man of Europe", supposedly coined by the Russians in an attempt to persuade Britain into an alliance against the empire in which they would divvy up the spoils of the vast land.[1] Soon after, the Ottoman Empire won the Crimean War and favourable terms in the Treaty of Paris (1856), which guaranteed its territorial integrity and allowed it to join the 'Concert of Europe'. The empire wasn't so sick after all. Nonetheless, continuing European interest in its territories, coupled with the post-imperial nationalism of the Republic of Turkey, have often painted the later years of the empire as trapped in out-dated and conservative practices of the "East" set in contrast with the modern, signalled through practices of the West. The implicit binary between an already modern West and a rest of the world engaged in modernizing in order to resemble it has often hidden the parallel development of modern movements such as feminism.

Yet as part of the global legacy of the Enlightenment, the Ottoman Empire had been grappling with the changes of modernity in concert with Europe since the end of the eighteenth century. At times, this meant importing European technology and instruction, as signalled by the massive reforms of the Ottoman military which established a modern fighting unit in the 1790s, ultimately re-sulting in the elimination of the historical Janissary order in 1826, the establish-ment of a new administrative system in 1839 (beginning an era of bureaucratic reordering called the Tanzimat) and a fully modern military chain of command by 1842. No longer organised by religious affiliation, the newly equalised citi-zenry of the Ottoman Empire enjoyed the benefits of modern urban planning — straight streets, orderly neighbourhoods, and public services — as well as modern education.

Since the late eighteenth century, modern education had been available for military cadets. The 1869 education act established primary education for both girls and boys, and a Teachers' Training College for Women in 1870 became the first public resource for women outside of elite families in a time when public women's education was also newly developing in Europe.[2] Nonetheless, legal assurances did not always suffice to guarantee the rights of women: by

1 de Bellaigue, Christopher, "The Sick Man of Europe," *New York Review of Books*, 48:11, July 5, 2001.

2 Summaries of Ottoman history abound, and offer extensive in-formation on the Tanzimat era. A good work for non-specialists is, Caroline Finkel, *Osman's Dream: The History of the Ottoman Empire*, New York: Basic Books, 2007.

3 Alexander Safarian, "A History of Turkish Feminism," *Iran and the Caucasus*, 11:1 (2007) 141–151; 144.

1874–1875, there were still only twenty-five elementary schools for women in the empire. Although leading reformers such as Ziya Gökalp and Namık Kemal in the 1870s sharply critiqued the forced marriage of underage girls, comparing it to slavery that had recently been outlawed, by the turn of the century polygamy remained a potent cause of public debate.[3] By the 1880s, various women's magazines emerged, giving women a voice and a space to debate in the public sphere. The nature of femininity, the role of women and their equal subjectivity and intellect with men were frequent topics of discussion. During the same period, women authors like Fatma Aliye (1862–1924), daughter of the leading government reformer Ahmed Cevdet (1822–1895), and the poet Nigar Hanım (1856–1918) entered the published public sphere. Reform was also never without loss: just as historic buildings were mowed down and cut in half for the construction of roads, regularisation entailed a retreat from diverse forms of Islam, such as widespread and gender-egalitarian Alevite practice, that had coexisted, naturalizing our own era's anachronistic projection of a singular, "orthodox" Islam that emphasises patriarchal interpretations of religious identity. Yet reform was something so constant that the question was not whether to change, but how.

The issue of change came to a political head when Sultan Abdulhamid II (r. 1876–1909), who ascended to the throne after a violent coup that had overthrown the reigning sultan in favour of a son who could not fulfil the role, decided two years into his reign that the constitutional monarchy instituted at the time of the coup and establishing a parliament in 1876 would be too threatening to state stability. Enduring oppositional movements, eventually known as the Young Turk Movement, emerged in the primary institutions of modernisation, the medical and military schools providing education to elite Ottoman youth. Developing into the party of Union and Progress (Ittihad ve Terakki), the movement eventually included notable women such as Halide Edip (Adıvar; 1884–1964) and Fatma Aliye's sister, Emine Semiye (Önasya; 1864–1944), who argued in favour of women's participation as an integral part of the reform movement.

Born in 1874, Azade's father Selim Sırrı (Tarcan; 1874–1956) thus came of age in an era when issues of women's rights had already become an important part of the reform movement, and many elite families had taken leadership roles in the education and public voice of women. Born into an established military family, he was part of the elite who attended the private, French-language Galatasaray School, from which he later transferred to the public Royal Technical School of Naval Engineering. There he excelled in physical fitness, becoming one of the first football players of the country by the turn of the century.

Both in the later years of the empire and in the early years of the Republic of Turkey, he led its Olympic committee and sports education. Ironically, as his charismatic promotion of civil liberties drove him forward in the leadership of the Young Turk Movement, it also became threatening as they acceded to power following the deposition of Sultan Abdülhamid II in the Second Constitutional Revolution of 1909, resulting in his temporary and educational exile in Sweden.

The gymnastics developed by Pehr Henrik Ling (1776–1839) that inspired Selim Sırrı to promote physical education in the Ottoman Empire is actually very familiar in our world; it was also the inspiration for the types of posture-based yoga that has become a mainstay particularly of educated Western women today. Although often associated with ancient Indian meditative practices, the term was incorporated with revived spiritual practices and applied to appropriated British "physical culture", introduced at the YMCA in India starting in 1857 Calcutta and soon spreading throughout the colony as part of anti-colonial Indian nationalism against British images of native peoples as weak.[4] As in India, Selim Sırrı sought to develop the whole person as an essential element of modernisation in a revolutionary era. He was also partaking in two elements of global modernity: the reintegration of mind and body in consideration of the whole person and the idea of strength as a significant element in the development of national, and implicitly anti-colonial, identity.

In this he was not alone. During the same era, Rıza Tevfik's (Bölükbaşı) 1909 article, 'Dance and Its Various Forms in Ottoman Countries' incorporated regional dance practices of Ottoman regions into a broader consideration of proto-national folk dance. Likewise, Mehmet Fetgeri Şuenu wrote articles promoting physical education for women as part of the creation of a strong and healthy nation. Selim Sırrı drew on this work in developing the Aegean Zeybek dance from its folk form to a formalised performance to be engaged as a social dance in accordance with European practices.[5] As a young man, he worked with men of the Ottoman elite to spread the idea of exercise as a road to health.

As Selim Sırrı developed his ideas about movement and dance in their application to the Ottoman World, he and his wife raised two daughters: Selma, born in 1906, and Azade, born in 1908. Although perhaps unique in its emphasis on physical strength, the European cast of their education was common for young women of late Ottoman elites, particularly in Young Turk circles. Girls like Selma and Azade often studied painting and music alongside French and English with European governesses. Elite Ottoman women often enjoyed the same liberties as their European counterparts, and many European women also

4 Mark Singleton. *Yoga Body: The Origins of Modern Posture Practice,* Oxford: Oxford University Press, 2010.

5 Arzu Öztürkmen, "Alla Turca: Transforming Ottoman Dance in Early Republican Turkey," *Dance Research Journal* 35:1 (Summer, 2003), 38–60.

married into Ottoman elite families, often as part of polygamous marriages. The girls had a German nanny as of 1910 and attended the German school until its closure during World War I. In an extensive article designed to present their education as exemplary to the young Turkish nation, Selim Sırrı wrote that his daughters were brought up close to nature, benefiting from sun, air and movement. In 1926, Selma Sırrı (Miroğlu) published the book for which she became known, *The Aesthetic Dances of Miss Selma Selim Sırrı*, in which she distinguished between the physicality of dance, inspired by the example of Isadora Duncan and European ballroom dancing, and the sensuality with which Eastern dance was often associated and denigrated. Although she and Azade both attended a gymnastics program in Berlin in the 1930s, Selma was more interested in the performative aspects of dance, while Azade focused on its therapeutic aspects—not as therapy for illness so much as therapy for the social illness inherent to the absence of movement in Ottoman women's lives.

Nancy's work *My Name is Azade (Freedom)* captures the first-person account of Azade's relationship with dance as though it were a simple documentary history. Yet the medium Nancy chooses, a sequence of drawings overlaid with handwriting and reminiscent of a graphic novel, places us within the subjective experience of the artist. Although we have not had the pleasure of meeting, talking to dancing with Azade, Nancy uses the intimacy of the medium to transfer Azade's experience to us. Nancy's handwriting not only stands in for Azade's, but also becomes her voice. The viewer feels as though she or he is reading a letter. To look into the eyes of the portrait of the young woman in the first image stands in for the experience of meeting an older woman telling us of her youth. Through her eyes, then, we see her father, the lion of constitutionalism. As with the portrait of the young woman, the transformation of this posed photograph into a drawing lends it the intimacy of a woman remembering her photograph through the vehicle of a photograph which we can imagine her showing us. Where the photograph would have served as a document, here the drawing serves as memory.

The work uses drawing as a unifying principle of memory that can bring together multiple photographic sources in a single format. Whereas some photographs may come from family albums, others may be historical resources related more to Ling gymnastics than directly to the experience of Azade, and still others—such as the image of her father as a muscle man—may be real, or may also be pure fiction. We do not need to know which in order to understand them as reality. Much as we look at the photographs of others to refresh our own memories, these drawings enable us to incorporate external sources into Azade's life story.

This life becomes the memory not simply of an individual, but also of a nation beginning to grapple with the individual and concrete application of abstract concepts like liberty and democracy. Her father's vision was that these are not abstractions, but that they must first be realised in our selves. Our freedoms must emerge not only in our minds, but also in our physical selves. In his mother's resistance to his attraction to sports, we come to understand how radical his idea was that our selves, male or female, are actually bodily and require physical expression. In the world suffused with change in which he lived, he had the good fortune to set these radical ideals in motion not only in his own family, but also in society at large.

By shifting the well-known history of a great man to the voice of the lesser known of his two daughters, Nancy articulates her own entrance into the complex histories of gender in Turkey. Inserting herself into the first-person narrative of Azade at the end of the work, Nancy establishes a direct connection between herself and her teacher, transforming a plethora of private memories collected from Azade's friends and family, as well as her short instructional films, into a public record. While we neither experience Azade's movement in her own body nor view any direct photographic record of her image, we experience how her hopes and work live on in *Passing On II* (2015), an artistic video in which Nancy enters the role of Azade teaching the younger women of her own life the gymnastics of Azade. In doing so, Nancy propagates the vision of a hundred years ago to a new generation. The intimacy of drawing shifts towards the intimacy of family.

What does this mean in modern Turkey, where the freedoms and choices of women continue to be marked and re-assessed based not simply on their opportunities for education and participation in the public sphere, but in the freedom and politics of their bodies, and implicitly of their sexuality, as marked in covering their hair? What does it mean as the entire project of national modernism that characterised the Middle East in the twentieth century is threatened through new forces of capitalism, Islam, and war? In remembering Azade, we remember an era of hope, in which the actions of an individual held out the promise of changing the practices of a nation, and we can only hope to live again in such a time of promise.

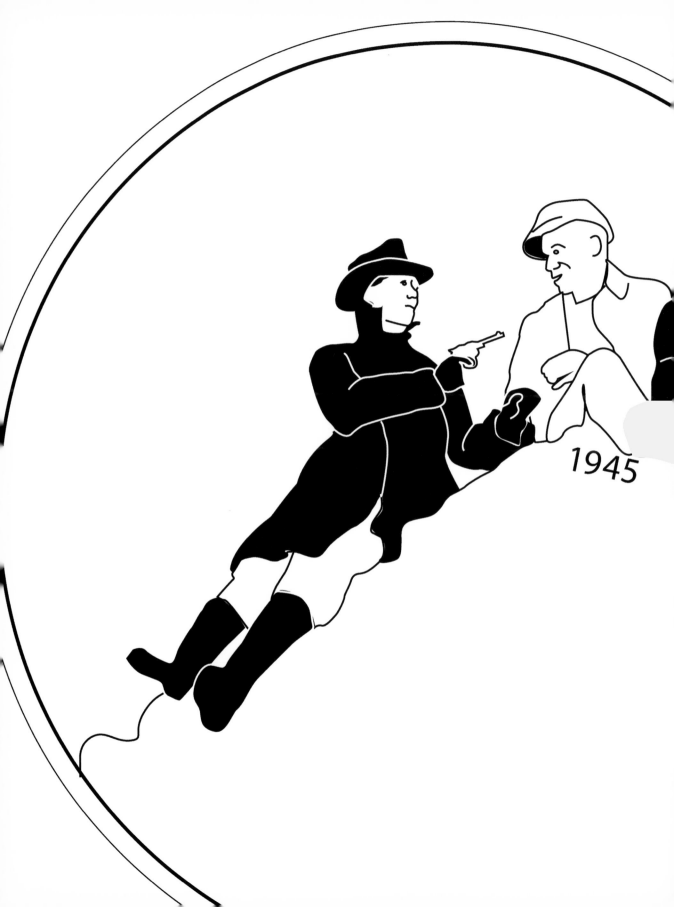

On Stories, Bodies and Collectivity:
An Interview with Nancy Atakan

Merve Ünsal

Nancy Atakan extends her research from family archives to the reconstruction of past moments and situations by employing a range of media, including image-based installations, photography, video and neon—a series of experiments and forms that have become central to Nancy's questioning of the female body in both social and cultural contexts.

Nancy and I first met through 5533, the artist initiative that she co-founded, where I had my first solo exhibition in 2013. We have since been talking about many things—from what it means to found an initiative in the ever-fluctuating context of Istanbul to what it means to study art history alongside your artistic practice. The notion of dialoguing with other artists across different generations permeates Nancy's practice. Her work remains timely and poignant, and her combination of conceptual investigations with personal experience and history point to a desire to relate both to the art historical canon and to knowledge production in the visual arts through research-driven methods.

Merve Ünsal: In your most recent work, *Passing On II* (2015), a video showing women and girls learning a choreography in front of the camera, the female body is the subject. In many of your other works, including *Mirror Fetish* (2013) and *And* (2007), we see your body. Where is the female body located in your works? Where is *your* body located? What happens to the female body in the historical and geographic contexts within which you produce your works?

Nancy Atakan: I wanted to use myself in my artwork. Traditionally, patriarchy has used the female body, but if anyone is going to make artwork about my body, if anyone is going to express feelings using my body, it should be me. In all the works in which I use myself I deal with beliefs about what it is to be a woman and to be viewed as an object. I believe there is something spiritual about doing this. When making *Passing On II*, I was thinking about the female search for professional role models. Since we learn everything by copying—even how to speak, even how to make art—this is essential. As women, whom do we look up to? If we imitate men, we are not being true to our "real" selves. This is changing for your generation, but as a woman artist from my generation, how many female artists could I look up to? This is not just true for artists.

Forty years ago, if I did not want to be a teacher or a nurse, how many professional women could I find? Everyone looks to the preceding generation. Only after internalizing and modifying and perhaps discovering something new can we meaningfully pass on our interpretations to the next generation.

I also see women as the family storytellers. Women are the ones who pass on oral history. Physically, mentally and socially, it's women who pass on—not men. The first work that dealt with this form of storytelling was *Grandmother's Lace* (2004). From my mother-in-law, I inherited a trunk of lace work that my husband's grandmother had made. In 2004, my mother-in-law had passed away and there were only a few women of her generation still alive. They were a minority group who had been forced to immigrate to Turkey from Thessaloniki, Greece, after the Republic of Turkey was founded in 1923. For this work, I interviewed elderly female relatives and videoed the beautiful lace they or their mothers had made. Neither women nor men from this group wanted to discuss their affiliation to the Jewish Sabbatian movement[1], but one of the men gave me the words to a Sabbatian prayer. Together with a Jewish music theoretician, we made a sound piece. A typical example of my research-based practice, this could be seen as a precursor to the *Lost Suitcase* (2009) video and the *My Name is Azade* (2014) drawing series.

The video *Mirror Fetish* (2013) is more like a fairy tale. I am sitting having my hair styled in a hair salon that could have been taken directly from 'Snow White and the Seven Dwarfs'. I have done several works about mirrors and aging. In *Used To Be New* (2009), I sit in the bathroom and apply creams to my face. Of course, nothing changes. Wrinkles do not disappear and I do not get younger. In *I Am Not Who You Say I Am* (2009), I look at my reflection and apply make-up as I reject photographs attached to the mirror to show that neither the description of who I should be as taught by my mother, nor the dogma of the church I grew up in, nor the beliefs behind the flag of the country where I was born, nor the beliefs of the place I adopted, nor the reflection of my physical being in a mirror, describe who I am.

M. Ü.: How did your use of the female body evolve over time?

N. A.: In my first video, *Document* (1994), I sat behind a desk across from the camera reciting a tautological statement I had written while researching conceptual art for my doctoral thesis. Because this statement still has meaning for me today, I re-filmed it in 2011. The final work contains the process of its making. The work is a documentation of thought and process that has already happened. But if we think about the evolution of my use of the female body, in

1 Considered a Jewish apostate, rabbi and kabbalist Sabbatai Zevi (1626–1676) converted to Islam after his incarceration by Sultan Mehmed IV. In Turkey a small group of crypto-Jews called *dönme* (converts) still follow his teachings.

this video, my body is sterile, intellectual and distant. Gradually, this changed. In my digital print, *I Am Born Every Minute/I Die Every Minute* (2000), I use images of myself from ages 1 to 50. I show the physical change over time. In *Silent Scream* (2001), I protest. I look internally to find my feminine strength and, with it, I rebel. I find my voice filled with pain. In the animated film *Between Two Voids* (2006), it seems that I am depicting my life journey from birth to death, but actually it is the lonely, painful, isolated internal story about my struggle to make honest artwork that is true to myself. Early on, I wrote the poem *And*, a personal philosophy about the importance of relationships. The connections, the spaces in between people where we communicate or don't, where we touch others or don't, where we experience or don't, is the place where life flows and everything takes place. Over time, this poem has taken on many forms. Growing older has made me face loneliness and continuous loss.

M.Ü.: It is interesting that you mention this element of 'passing on' and the performative, as I have always found that there is something very intuitive in your practice. Repetition of different bodies, and the act of repeating something over and over, says something in and by itself. I would like to highlight this particular brand of feminism that I find to be important in your practice. Your feminism is by no means aggressive, but rather you are critically engaged with women's place in history through looking and working with what is already there. How do you integrate your criticality with your personal life and your body? How does your theoretical research come together with the personal subtext of your life as a foreign woman living in Istanbul?

N.A.: If we compare my video *Faltaşı* (1999) to my last video *Passing On II* (2015), there are many similarities. For both videos, I invited groups of women to come together and share an event. Process is important, as is sharing. In the video *I Believe/I Don't Believe* (2009), I am performing a repetitive act in which I drop evil eye beads into a bucket in a manner similar to pulling petals off flowers in the childhood game "loves me/loves me not". Since I did not grow up believing in the evil eye, I have had to struggle to incorporate this concept into my belief system. One belief system is not superior to the other. I also spent a year testing and trying to ascertain the reliability of Chinese fortune telling sticks. The end result, *Prediction* (2007), showed me sitting on something resembling an egg reading Chinese fortune sticks. I was trying to show how the Western desire to classify, rationalise and scientifically prove can become nonsense. My approach is very organic and I'm not very self-conscious about presenting women's place in history. For instance, if we look at *My Name is Azade* (2014), a work about my former gym teacher, we see that Azade's role model was her father. This is very typical for women born during the Ottoman

era who became professionals in the Republic of Turkey. Her appearance was not what we would typically call "feminine", nor was her demeanour. When I used myself in my artwork, I wanted to present a woman with all these things that are traditionally associated with the "feminine",—putting on make-up, using pink and colour, being concerned about hair-dos, etc. As an older artist, as a role model, I want to be loving, caring and maternal, but also to be respected because I am intelligent, professional, and a hard-working person.

M.Ü.: The way you use women in your work is very different from how you use images of men. When you use images of men, you use appropriation as a strategy. How do you frame this switching of the gaze, you becoming the viewer rather than being the object of the gaze?

N.A.: I look at men's bodies more from the perspective of how they relate to power, to authority and ideas of nations and nationalism. For example, *What Something is Depends on What it is Not* (2002) is made up of images of two men. One is of my father-in-law, an officer in the Turkish military, and the other one is of my father, a private in the American military. I did this work when the US invaded Afghanistan in 2001. What you are defines what you are not. If you are an American soldier, you are not a Turkish soldier. In WWII, Turkey did not go to war, so my father-in-law did not fight. My father got sick, so he didn't fight either. If my father had fought and if my father-in-law had fought, there is a possibility that neither my husband nor I would be here today. Who gets killed in these wars? Who lives and who does not? I don't really like the military, but I wanted to think about these two images and to reflect upon war and uniforms. During WWII, uniforms, regardless of nationality, were very similar. But when the US invaded Afghanistan, the military from different countries were dressed very differently. Their uniforms expressed more clearly where they came from, material status, rank and the position their respective countries took on the world stage.

M.Ü.: It might be interesting to think about the term 'objectification'. The objectification of the male body deals with how it is quantified: the number of martyrs, the number of soldiers. The male body is subjected to a completely different way of manipulation and exploitation than the female body.

N.A.: The soldier is of course being exploited by war. We must ask why and that brings us to the concept of the nation and nationalism. It was very interesting for me to think about how we can simultaneously show allegiance to nation and to humanity. In *What Something is Depends on What it is Not* (2002), I was also thinking about the allegiance between the US and Turkey, which has never

been an equal relationship. I made the two soldiers equal in size and they stand in front of relatively neutral backgrounds, though my father-in-law, as an officer, was more educated than my father, a private. As there is a socio-economic inequality between the two men, there is also an imbalance between their respective countries. When we look at this artwork today, it makes us think about the relationship between these two countries as it evolves and changes.

M. Ü.: You tend to deal with the macro through the micro, drawing on the personal and the smaller picture to make sense of the bigger picture. I wanted to ask how you relate to historical research in your work, specifically the rupture between the Ottoman Empire and the founding of the Republic of Turkey.

N. A.: Before starting work on *Lost Suitcase* (2009) and *My Name is Azade* (2014), I made some rules for myself. I would only look at women who influenced me—not just any woman born during the Ottoman period. While her family might be famous, she would not be particularly well known. She must be well educated, urban, highly motivated and professional. I had to work from my own lived experiences. I cannot make artwork from something I have not lived. In the Istanbul art scene, many artists make work about village women or those who live in urban ghettos—women who have struggled and who have been persecuted. I did not want to do work about these women because it would be based totally on research rather than on something I know firsthand. As a subject for artwork and research, the educated, accomplished and perhaps independently wealthy urban woman has been forgotten. But these women should not be forgotten. My generation and your generation should look up to these women who have forged a place for us in the work force. The women, the artists who have influenced me, are these women.

M. Ü.: You constantly use what is around you, what you see, what you encounter and sometimes serendipity. You have a PhD in Art History, which is an important part of your foundation as an artist. What does your practice as an art historian do to your work?

N. A.: The only time anything made sense to me was through art, by either reading about it or making work about it. I make artwork to understand my environment on my own terms. Initially, I could only understand how to make artwork by looking at art history. When I was a painter, I would do research about an artist's techniques. There was a moment when I was totally enthralled by American abstract expressionist painter Helen Frankenthaler and how she made her paintings. I tried to make work like her visually, not conceptually. There is a Turkish painter called Leyla Gamsız. I went to her exhibitions to look

at the colours she used. I loved her pinks and wanted to replicate them. One of her paintings hangs in the entrance to my apartment. I also use art history to understand history. Context is important. When I investigated conceptual art, it was because I wanted to see how other artists were questioning art, artwork, institutions and art-related systems because that was what I had begun to do. Eventually, I realised that just like abstract expressionism, conceptual art was a male-dominated practice. I was interested in language, research, collaboration and questioning art practices, but I was also interested in looking at society and culture from a female perspective.

M. Ü.: How do you situate your practice within the canon of feminist art in Turkey? Who are the artists that you have been in exchange with and what is the historical context in Turkey that you place yourself in?

N. A.: Is there a canon of feminist art in Turkey? I have not seen reliably researched comprehensive material written on this subject. However, my work was included in two important exhibitions presenting Turkish women's art: *Istanbul Next Wave* at Akademie der Künste in Berlin (2009) and *Dream and Reality—Modern and Contemporary Women Artists from Turkey* at Istanbul Museum of Modern Art (2011). In the latter, all my digital and video work using "me" as the protagonist was presented as a mini-retrospective. The video *Lost Suitcase* was included in the former. A wrong impression is created if my practice is evaluated alongside other Turkish artists of my age group. Artists such as Ayşe Erkmen or Gülsün Karamustafa, who are my age, were already established biennial artists before I began my present practice in the 1990s. My work should be discussed with artists from the next generation, such as Neriman Polat, Gülçin Aksoy and Gül Ilgaz. These are the artists with whom I began my career in the early 1990s. We finished studying at Mimar Sinan University at about the same time, shared a studio for several years and organised exhibitions together in alternative spaces. We were all interested in conceptual art and collaboration, and we also had political and social concerns. Being women, our work presented a feminine perspective. We no longer work together, but our practices share some similarities in terms of topics of interest. Now, I am learning from a younger generation of artists such as you. I see the art initiative, 5533, that I co-founded with artist Volkan Aslan as a continuation of my art practice that reflects the importance I place on collaboration, research and dialogue with others.

M.Ü.: Mimar Sinan University is as close to an art academy as it gets in Turkey. How did your training as an art historian at Mimar Sinan affect your work?

N.A.: Before I studied at Mimar Sinan, I was a painter using an abstract expressionist style. After writing my PhD thesis on conceptual art and the arrival of this Anglo-American-based practice in Turkey, I completely gave up painting and concentrated on concept. I am no longer a painter.

M.Ü.: You had been working in alternative spaces even before you founded 5533, like Karşı Sanat. How did these exhibitions originate and why did you self-organise?

N.A.: When my practice changed in the 1990s, very few artists were making videos, digital prints and installations in Istanbul. Commercial galleries were only interested in artists who were making paintings and sculptures. To be able to show what we wanted, we had to find our own space and finance the exhibitions ourselves. We did this for the series of exhibitions *Between* (1997), *Back-to-Back* (1998) and *Between '99* (1999). In 1997, we rented the top of AKM (Atatürk Cultural Centre). During this exhibition, at least one of the artists was always on site to explain the work. In a way, we legitimised digital prints and digital videos as acceptable art forms. Along with our exhibitions, we always organised discussions and debates.

Early in 2000, a polarisation had begun between those who were doing sculpture and painting and those making videos and digital prints. In a series of exhibitions at Karşı Sanat in 2000, 2001 and 2003, we addressed this issue by inviting painters and sculptors to exhibit with us. In this exhibition series, we worked without a curator and self-organised, more out of necessity than to prove a point. We also dealt with local issues and tried to focus on the situation personally, socially and culturally. For us, collaboration had always been important and that was always an integral part of the process.

M.Ü.: What do self-organisation and artist-driven initiatives mean in terms of historicisation in a context like Turkey's?

N.A.: In the 1990s and 2000s self-organisation and artist-driven initiatives came from a basic need. There were few institutions, few museums, and commercial galleries had a narrow viewpoint. In 2010, there were around 20 local initiatives, but gradually they became institutions, moved to another country or closed. Early initiatives aimed to stay outside the market and emphasised collaboration. Today, new initiatives seem to model themselves after commercial galleries and aim to promote artists hoping to find a way into the mainstream.

Works

My Name is Azade (Freedom)

23 pencil drawings with handwritten texts on paper, 30 x 40 cm (2014)

The drawings with handwritten texts are the result of research on Azade, Nancy's first gymnastics teacher in Turkey. The work, neither fact nor fiction, is based on interviews with Azade's relatives in Istanbul, a professor in the Sports Department of Gazi University in Ankara, and contacts in Sweden, where Azade's father had studied Ling gymnastics in the early 20th century. It continues the artist's investigation into professional women of the Turkish Republic born during the Ottoman period.

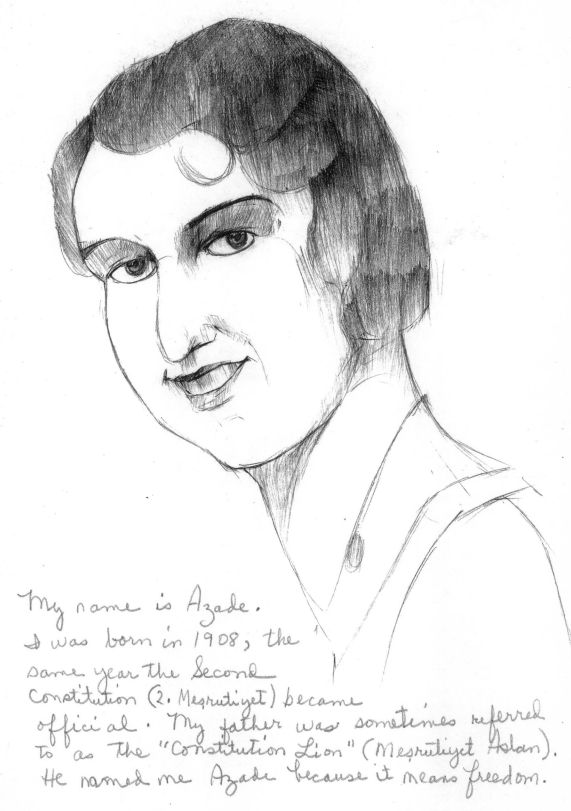

My name is Azade.
I was born in 1908, the
same year the Second
Constitution (2. Meşrutiyet) became
official. My father was sometimes referred
to as the "Constitution Lion" (Meşrutiyet Aslan).
He named me Azade because it means freedom.

Mae
2014

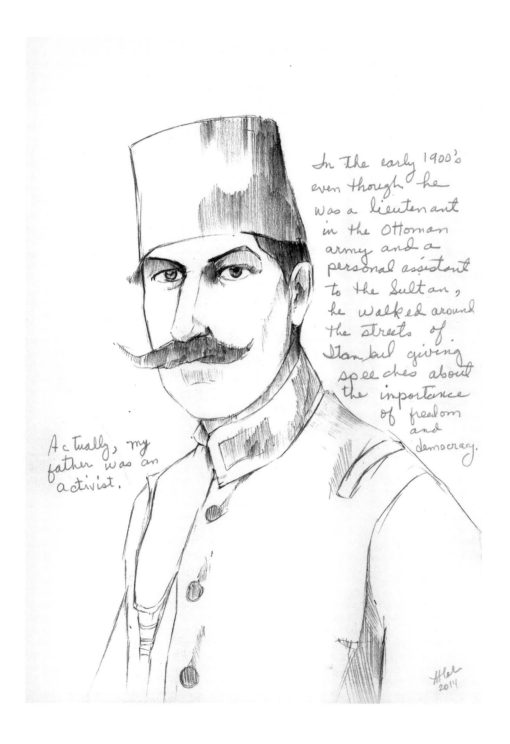

In The early 1900's even though he was a lieutenant in the Ottoman army and a personal assistant to the Sultan, he walked around the streets of Istanbul giving speeches about the importance of freedom and democracy.

Actually, my father was an activist.

Before going to Sweden, my father believed lifting weights to develop muscles was the secret to a healthy body, but in Sweden, he was exposed to a different philosophy. After a year as an observer at the Swedish Royal Physical Education University, he became an expert on Swedish life, Swedish massage, and Ling Gymnastics. Later, he trained my sister and I using the information he brought back from Sweden.

Muscles ≠ good Health

Swedish
Ling Gymnastics

Others say the Sultan
wanted to execute him
because of his popu
Spring of 1909, my

My father didn't tell us why he was sent abroad, but one story is that the head of the Young Turk Movement (Yön Türk Hareketi) got jealous because he was a charismatic speaker. To protect my father, a close friend and Minister of Defense assigned him to a position in Paris.

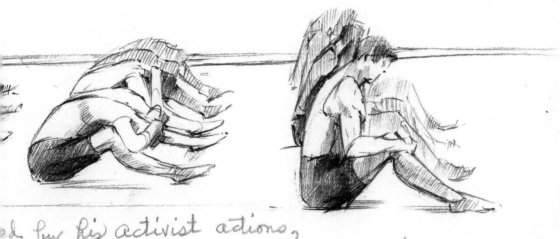

ed by his activist actions,
decided it best to send him abroad
What ever the reason, in the
went to Sweden to study Ling Gymnastics.
This experience changed
our lives.

Alat
2014

When my father returned
was assigned to a regio
Since I was small and
in the city to continue
activities, he resigned
military.

As a civilian
he continued to
walk in the
streets of Istanbul
to give
speeches.

Quit the Milit

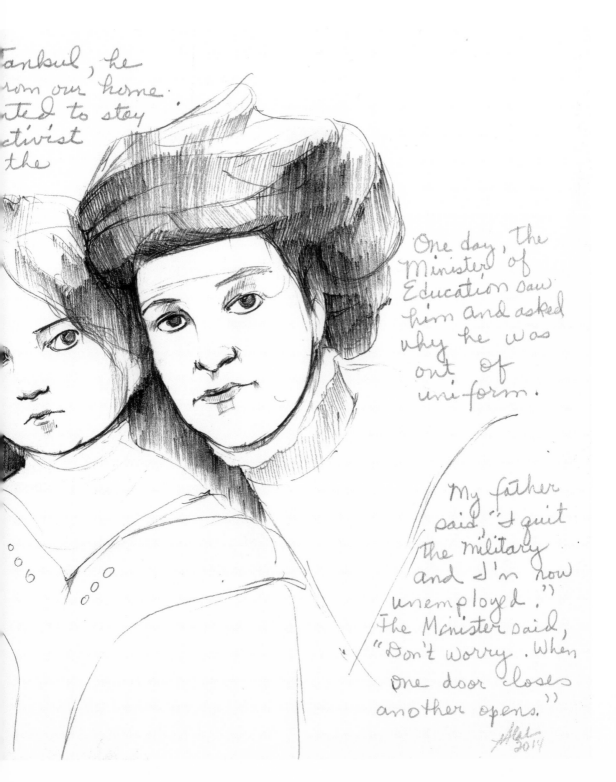

tanbul, he
rom our home.
ted to stay
ctivist
the

One day, the
Minister of
Education saw
him and asked
why he was
out of
uniform.

My father
said, "I quit
the military
and I'm now
unemployed."
The Minister said,
"Don't worry. When
one door closes
another opens."

Alal
2014

In a few days, he received an official
invitation to become the Inspector of
Physical Education in Istanbul schools.
He was shocked and asked what he
would inspect since
there were only a couple
schools giving
gymnastic lessons.

The Minister said,
"First, you add
classes and then
you inspect them."

Inspector of
Physical Education

Eventually, my father
became the inspector of
physical education classes in all
Ottoman schools.

Alev
2014

Exercise for Everyone (even women)

Around our crowded dinner table, my father told us stories about his campaign for change. He began by speaking with religious leaders (Iman) who were mostly fat and unhealthy. After convincing them that exercise would be good for their health, he started to give exercises to the highest religious leaders. At first they attended classes wearing their turbans, but quickly saw this was impossible. After several months of doing exercises regularly, they realized their health was improving. In this way he was able to convince them that exercise would be beneficial for everyone including women.

of course, we know that [...]
women in general was a pa[...]
modernization project t[...]
during the Ottoman peri[...]
but my father saw two
problems for developing
sports training.

First,
only male
teachers
over 60
could
teach
gymnastics
to females
and

cation of

e

gan

Second,
girls could
not move
easily with
their
heads
covered.

Physical Exercise for Women

Neal
2014

In 1926, my father opened a school in Istanbul to teach physical education to teachers and invited two male and one female Swedish Sports instructors to Istanbul.

Opened School for Teachers of Physical Education

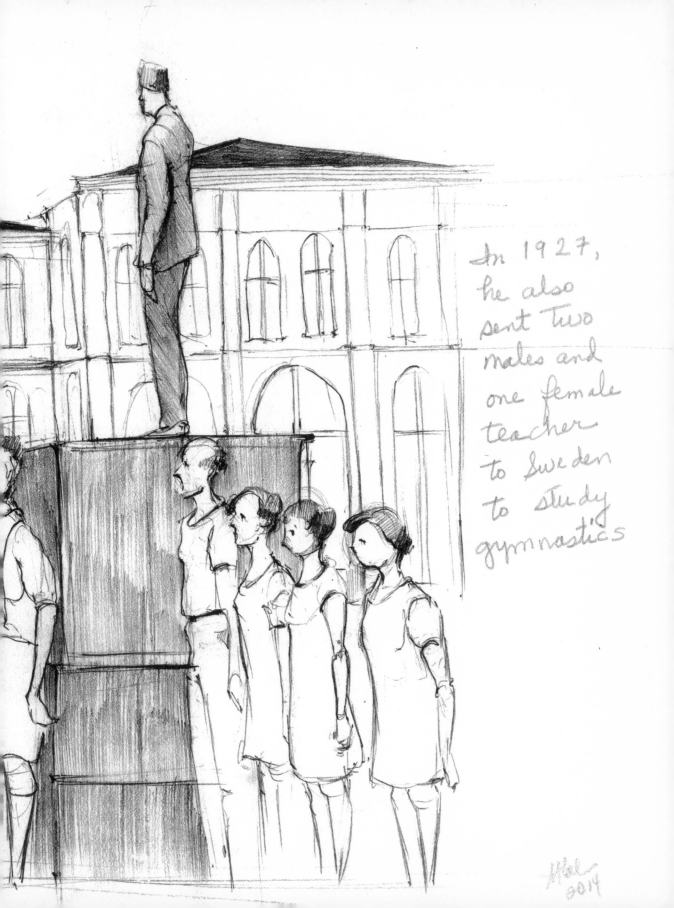

In 1927, he also sent two males and one female teacher to Sweden to study gymnastics

My father sent
my sister and I to Berlin
to study gymnastics.

My sister was
interested in
rhythmic
dance.

To some
extent, I was
also, but
for me
developing

a therapeutic
type of
movements
was
more
important.

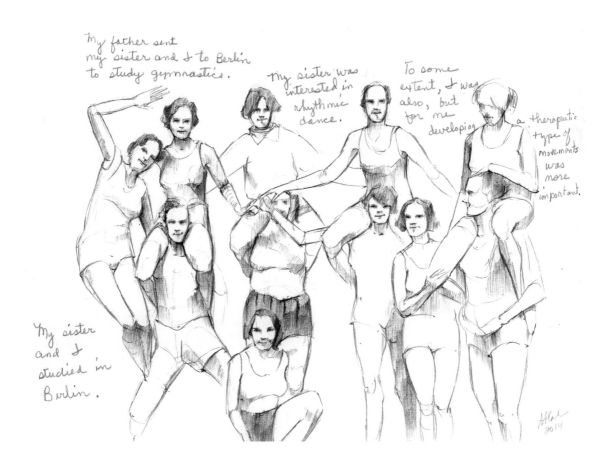

My sister
and I
studied in
Berlin.

The latest techniques

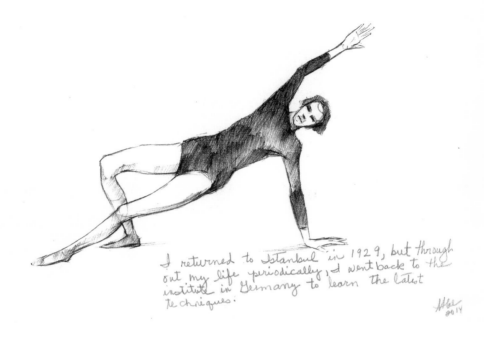

I returned to Istanbul in 1929, but through
out my life periodically, I went back to the
institute in Germany to learn the latest
techniques.

My father began to organize sport festivals as early as 1916. He wanted to instill a passion for gymnastics in the entire population.

He wanted to show examples of healthy strong disciplined youths. My sister and I helped him organize these festivals in the Taksim Stadium, a dirt field in the middle of the military school barracks that was located in the present Taksim Gezi Park.

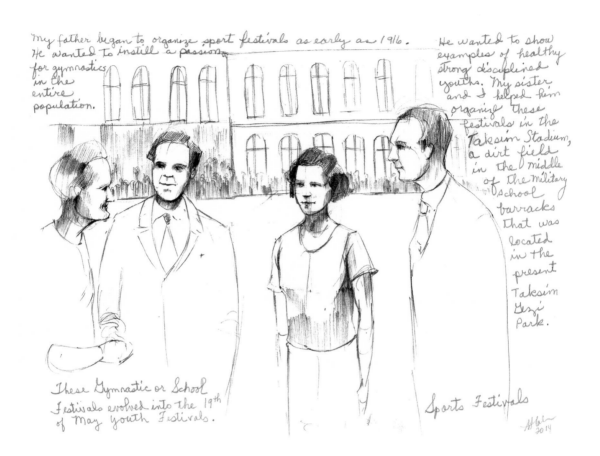

These Gymnastic or School Festivals evolved into the 19th of May Youth Festivals.

Sports Festivals

AKalan
2014

My father also took the music of a Swedish song, "Tre trallande de jäntor" (three singing girls), changed the words and altered the melody slightly to create what became a nationalistic march, "Dağ Başını Duman Almış." (Smoke on the mountain)

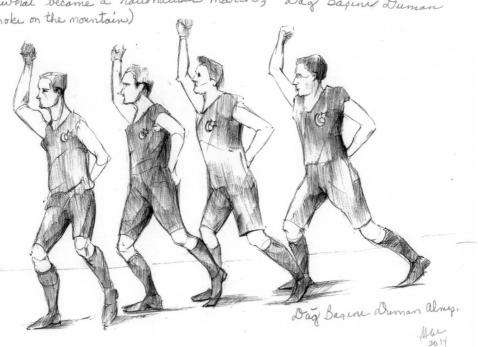

Dağ Başını Duman Almış.

A.A.
2014

He also transformed the Zeyb
by mixed couples in a ball
urban audience. He drear
dance like those he had seer
traveled with him to perfor
in Izmir he wore
performing the
whose idea

50

Dance into a form that could be performed
and appeal to a refined educated modernized
a Zeybek dance would become a national
iden. On occasion, my sister and I
seems humorous now, but I remember
a tuxedo while
Zeybek. I wonder
this was?

Zeybek Folk Dance

My sister and I were part of the Ottoman Elite and had ample opportunities to develop our talents and interests. We had a German nanny. We learned French and German. We took private ballet and piano lessons from foreign teachers. Our father and mother taught us literature and physical education. While we were in our late teens and early twenties effort to emancipate Ottoman women

broaden opportunities for their education and employment as well as expand their legal rights and ban arranged marriages reached a peak.

As a family we were avid supporters of these innovations.

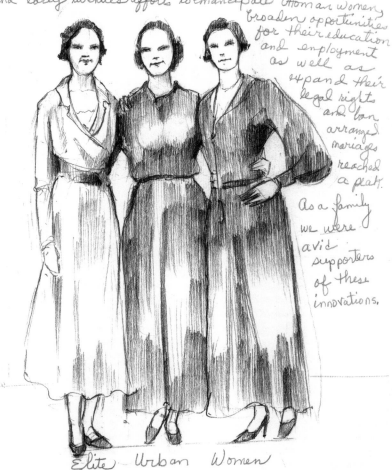

Elite Urban Women

Abel
2014

Influenced by Isadora Duncan, my sister wrote a book about dance and explored various ways of introducing modern dance to women of the Republic. Of course, I supported her efforts and participated in projects aimed towards giving modern dance a respectable status. All of our work could be seen as a part of the overall westernization program that began in the Ottoman period and continued in the Republic.

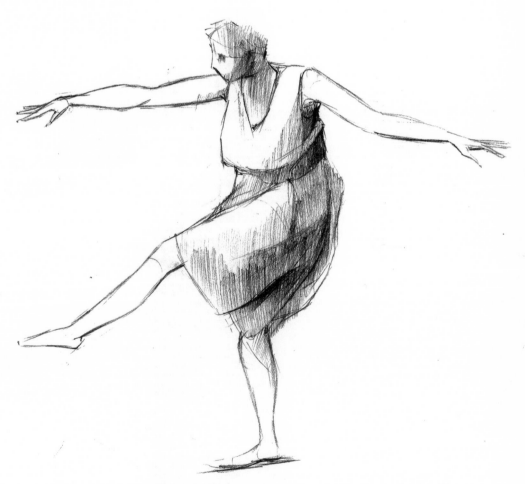

Modern Dance Becoming Respectable

Th

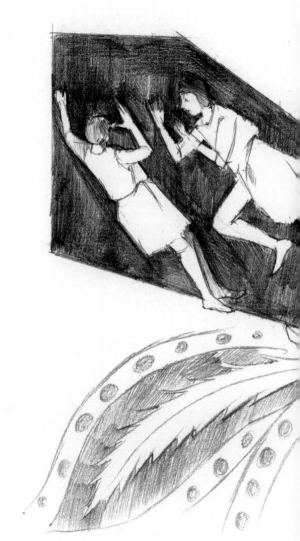

In 1934, my sister and
the newly opened Ant
but also trained stu

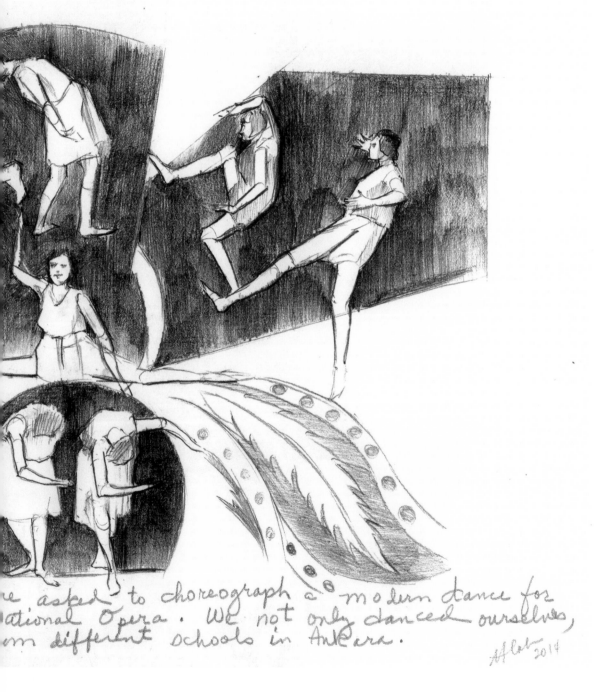

...e asked to choreograph a modern dance for
...ational Opera. We not only danced ourselves,
...om different schools in Ankara.

AFletcher 2014

Radio first came to Turkey in 1932 as a five to six hour broadcast every evening. As the first program each night, my father gave lectures about the cultured modern way of life. Either my sister or I would play the piano while the other performed movements. Our father watched us and described our movements on the radio. Our program was very popular. We heard that while Nazım Hikmet was in prison, he said that he wished he had a radio so he would listen to our program.

Our Radio Program

As a member of Parliament, my father was
highly respected and we greatly benefited from
his fame. When I started to give advise about
weight loss to beauty queen candidates,
I received a lot of
criticism. Many
believed that only
doctors should be
allowed to give
advise about weight
loss. My father
supported me and
the Minister of Health
decided in my
favor.

Beauty Contests

58

Both my sister and I married, my husband
worked in advertisement and produced silk
screenprints of Ottoman calligraphy. My sister
moved to Ankara. My parents, my husband, my
son, my neice (after my sister's death), and I
lived in a two-story brick house in Nişantaş
that had a wooden floored gymnasuem with
a grand
piano.
My sister
died at
an early
age and
I raised
her
daughter.

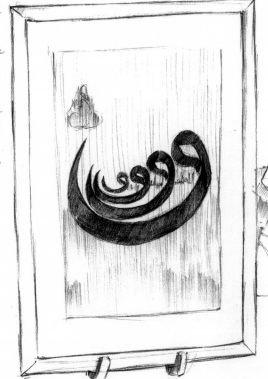

We had personal wealth, but my
father received a considerably large
salary from the government. He even
had a body guard who stood outside
the house.
 Silk Screen Printing

Alet
2014

Private Gymnastic Lessons

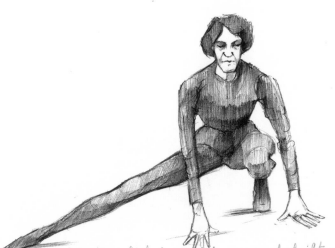

We eventually demolished the house and built an apartment complex in 1970. After my parents and then my husband died and my neice moved To the USA and my son to Austria, I gave private gymnastic lessons to people of all ages in the bottom floor of this Nişantaşı building. When I was retiring 80 years old, my son insisted I stop work, sell our property and move to Austria where he worked as a professor of music. AHakan 2014

I continued to give lessons to elderly people in the Austrian retirement home where I lived until my death. I wasn't able to write a book about the techniques I developed, but I made a video tape of myself performing movements and gave it to some of my students before I left Istanbul. I am pleased that Nancy Atakan kept this tape all these years. I do hope future generations will benefit from my years of research and experimentation.

My Unique Technique

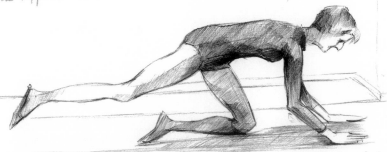

Yes, my father influenced me, but I became an independent woman in the Republic and I developed my unique working method. Some say my exercises were eclectic and incorporated elements from yoga, physical therapy and even pilates.

Alex 2014

All I can say is that I was always
a dedicated, strict and disciplined teacher.

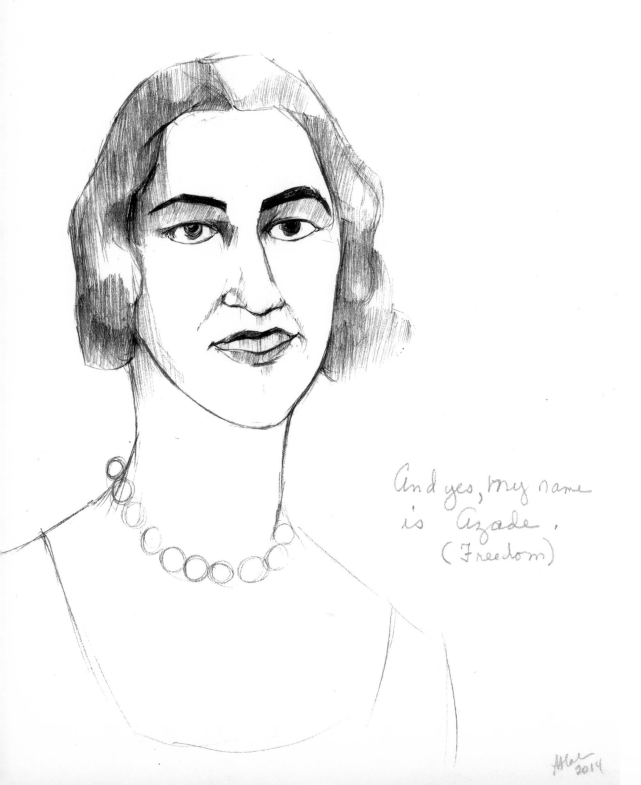

And yes, my name
is Azade.
(Freedom)

Passing On II

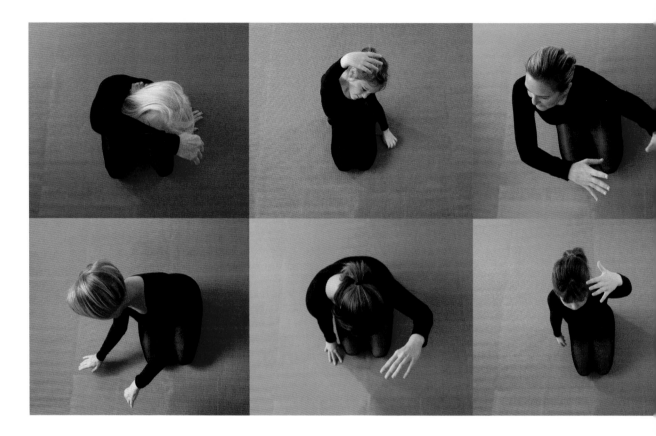

Double-channel video, 4'12" (2015)

For 35 years, Nancy kept an exercise VHS tape made by her first Turkish gymnastic therapist, Azade. She selected four movements from Azade's original video to replicate together with other women and young girls as a metaphor for the female search for role models.

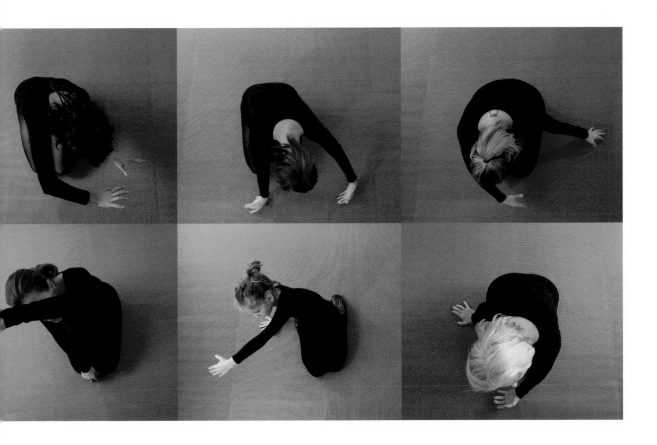

1935, 1945, 1955, 1965, 1975

5 silkscreen prints on silk, 75 x 75 cm (2012)

The five scarves resemble square European-style silk head-
scarves that were first manufactured in Turkey in the 1930s.
The designs are based on the artist's family photographs.
From 1930 to 1980, urban middle-class women in Turkey
would wear this type of scarf as a fashion accessory without
religious or political connotation. After the passing of the
1980s regulation that female civil servants' head must be
uncovered, urban secular women would no longer casually
wear these Western-styled headscarves because any head
covering now took on a political meaning.

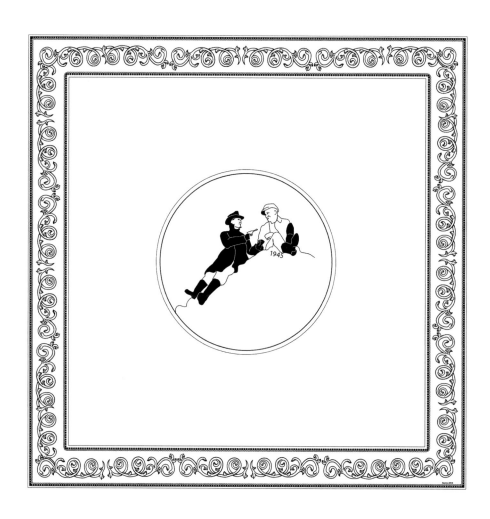

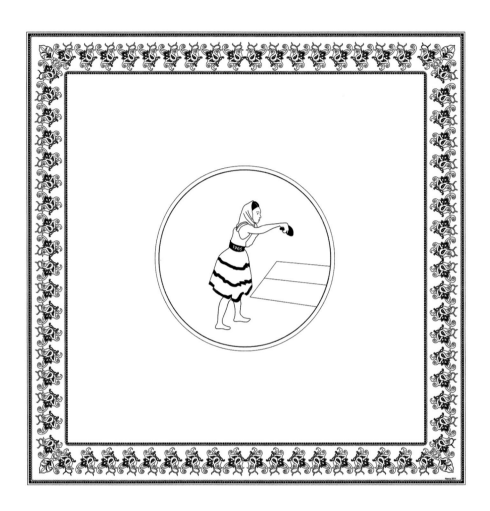

1980

Silkscreen print, handwritten text on silk,
50 x 1125 cm (2012)

Civilized mothers
Civilized wives
1839 to 1876
Second Constitution
1908 to 1919
Freedom for men
educated bourgeois women
school teachers and nurses
Only women can liberate women

Patriotic wives and mothers
Public Showcase
Employment of women
Women to educate nation
War of Independence
peasant women fight
behind lines

Heaven is a heartless land
Den of intrigue and trouble
Home
powerful fathers
strong households
Public Sphere
Showcase of modernity
Definition of Nation
Only protect honour with brain
Bodies as definition of nation
Bodies as public texts
Showcase/secret = public/private
Professional women
Symbol of Republic

The entire text on the scarf consists of sixteen paragraphs.
Only the first three are presented here.

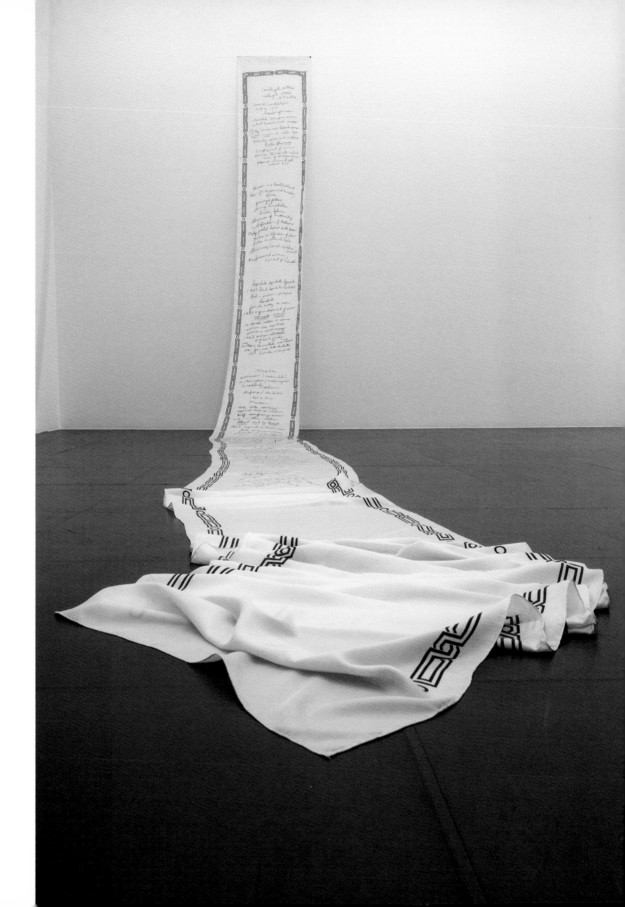

Father Knows Best

English and Turkish silkscreen print, 50 x 70 cm (2011)

The American 1950s television comedy series *Father Knows Best* (1954–1960) depicted a perfect middle-class American family. Stills from the episode 'Betty, Girl Engineer', conveyed the message that engineering is an inappropriate profession for women. In this work, video stills appear with captions in English and their Turkish translations. They have been transformed from one mode of popular exchange, a television program, into another, the *photo-roman*. It points out that seemingly innocent television programs are far from innocent, but rather laden with ideology and societal values.

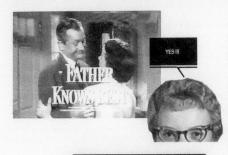
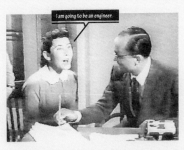
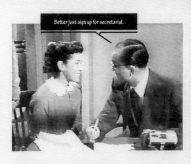
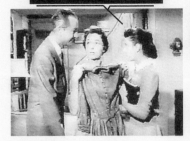
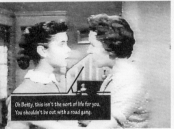
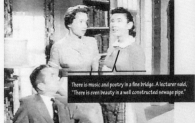
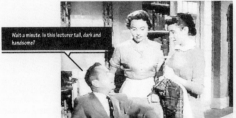
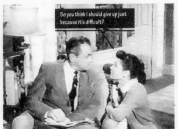
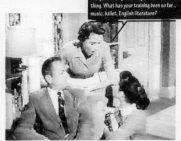
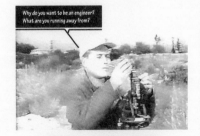
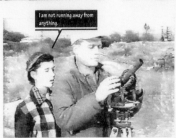
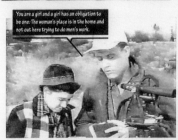
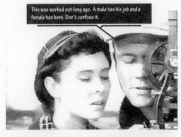
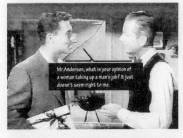
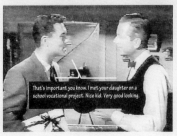
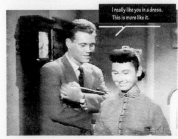
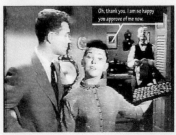
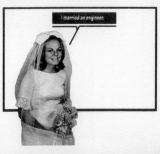

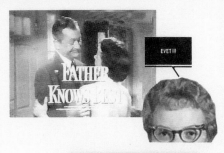

EVET !!!

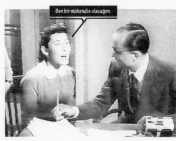

Ben bir mühendis olacağım.

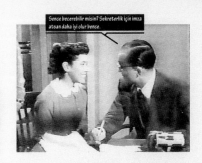

Sence becerebilir misin? Sekreterlik için imza atsan daha iyi olur bence.

Ben ne yapmak istediğimi buldum. Mühendis olmak istiyorum.

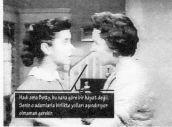

Hadi ama Betty, bu sana göre bir hayat değil. Senin o adamlarla birlikte yolları aşındırıyor olmaman gerekir.

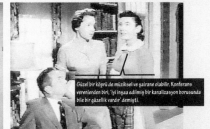

Güzel bir köprü de müziksel ve şairane olabilir. Konferans verenlerden biri, 'iyi inşaa edilmiş bir kanalizasyon borusunda bile bir güzellik vardır' demişti.

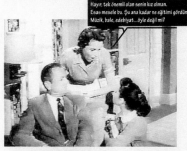

Hayır, tek önemli olan senin kız olman. Esas mesele bu. Şu ana kadar ne eğitimi gördün... Müzik, bale, edebiyat...öyle değil mi?

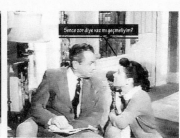

Dur bakalım... Şu konferansı veren nasıl bir adamdı? Yakışıklı mıydı?

Sence zor diye mi vaz mı geçmeliyim?

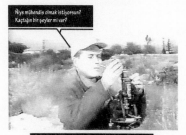

Niye mühendis olmak istiyorsun? Kaçtığın bir şeyler mi var?

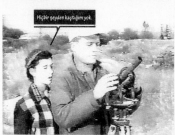

Hiçbir şeyden kaçtığım yok.

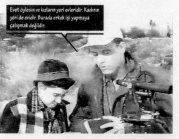

Evet öylesin ve kızların yeri evleridir. Kadının yeri de evidir. Burada erkek işi yapmaya çalışmak değildir.

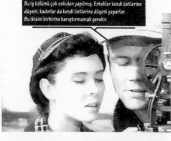

Bu iş bölümü çok eskiden yapılmış. Erkekler kendi üstlerine düşeni, kadınlar da kendi üstlerine düşeni yaparlar. Bu ikisini birbirine karıştırmamak gerekir.

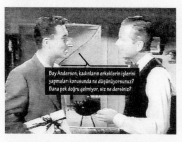

Bay Anderson, kadınların erkeklerin işlerini yapmaları konusunda ne düşünüyorsunuz? Bana pek doğru gelmiyor, siz ne dersiniz?

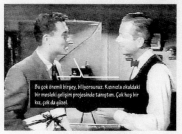

Bu çok önemli birşey, biliyorsunuz. Kızınızla okuldaki bir mesleki gelişim projesinde tanıştım. Çok hoş bir kız, çok da güzel.

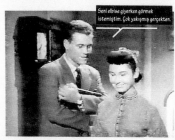

Seni elbise giyerken görmek istemiştim. Çok yakışmış gerçekten.

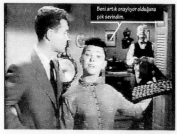

Beni artık onaylıyor olduğuna çok sevindim.

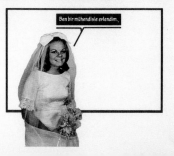

Ben bir mühendisle evlendim.

Referencing and Silencing

Digital print, 100 x 140 cm (1998 [reprinted in 2000/2011])

Two paradoxical images are combined: French 19th century Neoclassical painter Jean-Auguste-Dominique Ingres' 1908 oil portrait of painter François Marius Granet and a 1930s snapshot of an Istanbul lady. The resemblance is striking and cuts through historical and gender divides. Who is Western? Who is Oriental? Who is imitating whom? Who is the 'other' here?

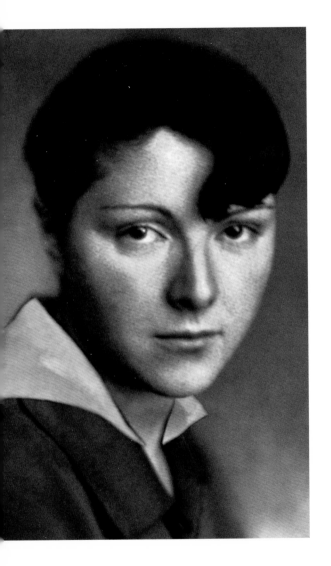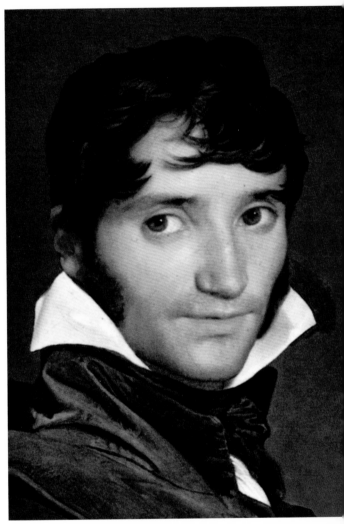

What Something Is Depends on What It Is Not

2 digital prints, 50 x 70 cm (2002)

Designed for a billboard located beside an advertisement for the Istanbul Military Museum, this work has only been exhibited as a digital image. The figures in the prints are the artist's American father and her Turkish father-in-law. Both men served during WWII. An inquiry into military alliances, nationhood, belonging and uniforms, the artist made this work shortly after the USA invaded Afghanistan in 2001.

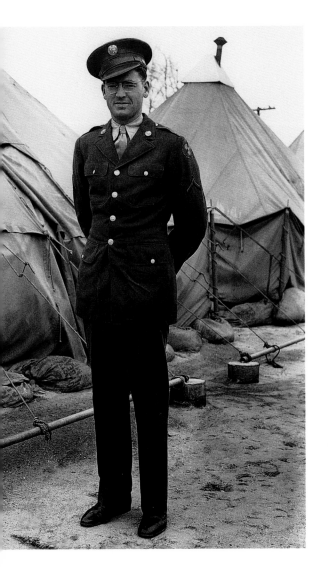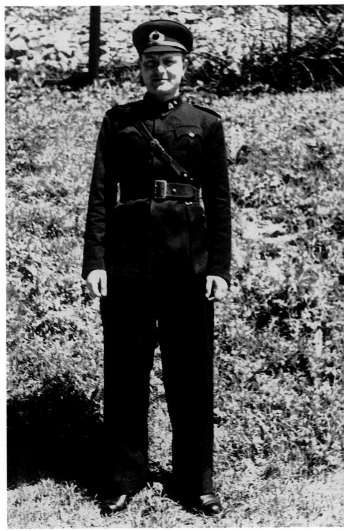

Lost Suitcase

Single-channel video, 3'36" (2011)

This silent video presents a love story between the artist's Turkish in-laws during their time in Germany just prior to WWII. Using family photographs, documents, and stories told by her mother-in-law, the work documents a specific era and lived experience. By using first person narration in a style reminiscent of old black and white films and incorporating memories and personal photographs, the artist transforms reality into fiction.

Enver and I fell
in love.

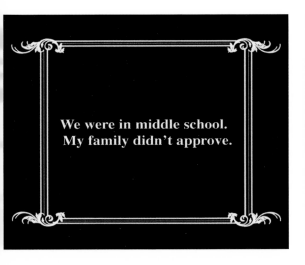

We were in middle school.
My family didn't approve.

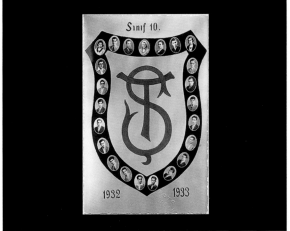

Sınıf 10.

1932 1933

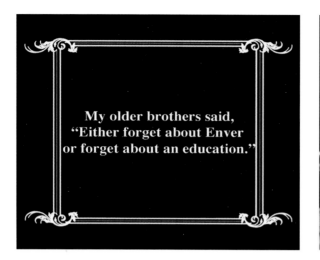

My older brothers said,
"Either forget about Enver
or forget about an education."

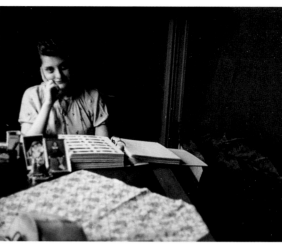

We met secretly and
wrote to each other
using Ottoman script.

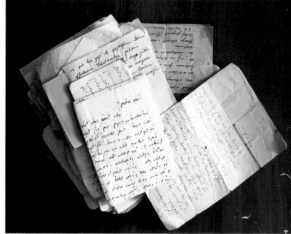

During the summer,
Enver rowed from
Suadiye to Burgaz Island.
We looked at each
other from afar.

We graduated and got
permission to get married.
We lived with
my elderly mother.

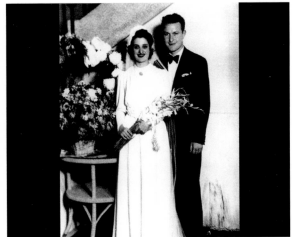

We traveled to Germany
in November of 1938.

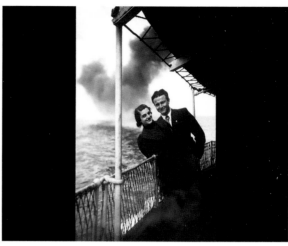

We were forced to leave
a suitcase behind.

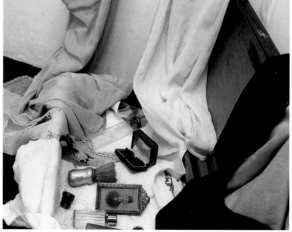

After ten months, we
realized war was going
to break out.

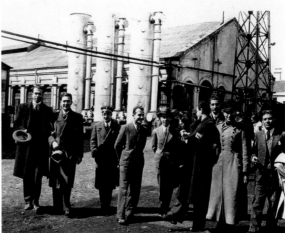

When we got to Istanbul,
my feet were swollen.
I realized I was pregnant.

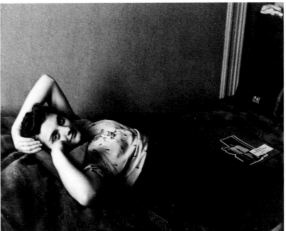

Still Waiting

C-print, 200 x 300 cm (2012)

This work shows an enlarged 1938 family photograph of
the artist's extended family-in-law, who were participat-
ing in a mock protest during the National Sovereignty
and Children's Day holiday. In the snapshot, children hold
signs asking for clean air, experienced midwives, respect,
attention, and cessation of abuse. We wonder whether or
not their demands were ever met over the course of the
years. It seems that today, like in the 1930s, many Turks are
still waiting for their many grievances to be addressed by
the government.

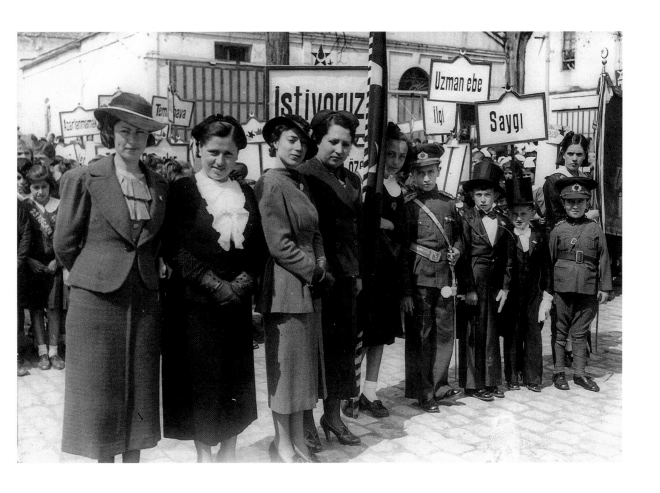

Artist's Biography

Nancy Atakan was born in Roanoke, Virginia, USA, in 1946. Since 1969, she has been living and working in Istanbul, Turkey, as an artist and art historian, where she co-founded the artist initiative 5533 in 2008. Her artwork has been represented by Pi Artworks since 2009. Atakan holds a BA in studio art from Mary Washington College, Fredericksburg, Virginia, USA, and an MA in education from Boğazici University, Istanbul, Turkey. In 1995, she earned her PhD in art history from Mimar Sinan University, Istanbul, Turkey. Atakan taught in the Art Department of Robert College, Istanbul, Turkey, from 1983–1997 and lectured at Boğazici University, Istanbul, Turkey, from 1996–2000.

Solo Exhibitions:

2014 *Incomprehensible World*, Istanbul Culture and Art Foundation (IKSV)
Hamlet Theater Festival, Istanbul, Turkey

2013 *Mirror Mirror on the Wall*, Pi Artworks, Istanbul, Turkey

2011 *How Do We Know We Are Not Imposters?* Pi Artworks, Istanbul, Turkey
From Here, 1970–2011, Pi Artworks, Istanbul, Turkey

2009 *I Believe/I Don't Believe*, Pi Artworks, Istanbul, Turkey
Holding On, Apartment Project, Istanbul, Turkey
Obsession, Manzara Perspectives, Istanbul, Turkey

2007 *And*, Proje 4L Elgiz Contemporary Art Museum, Istanbul, Turkey

2003 *People Objects*, Artoteek Schiedam, Rotterdam, Holland

2002 *Lives within Lifetimes*, the International Longevity Center, New York, NY, USA

2000 *And*, Mary Ogilvie Gallery, Oxford University, Oxford, UK

Selected Group Exhibitions:

2015 *Little Faces, Big Bodies*, Elgiz Museum of Contemporary Art, Istanbul, Turkey
Stay with Me, Weserburg Museum, University Bremen, Bremen, Germany

2014 *40 Videos from 40 Years of Video Art in Turkey*, 25th Ankara International Film Festival, Goethe Institute, Ankara, Turkey
The Feeling of Happiness, Homa Art Gallery, Teheran, Iran

2013 *Me, Myself and I, Me as a Dilemma*, CerModern, Ankara, Turkey

2012 *Keep on Keeping on*, Treibsand Art Space on DVD, Zurich, Switzerland
Places of Memory—Fields of Vision, Festival of Invisible Cities—A Cosmography, Contemporary Art Center of Thessaloniki (CACT), Thessaloniki, Greece
Who Left? What Behind, Ankara Contemporary Art Center, Ankara, Turkey
Familiar, SPAS Gallery, Rochester Institute of Technology, Rochester, NY, USA
Trading Stations, Curve Gallery, Parallel Event to Liverpool Biennial, Liverpool, UK

2011 *Dream and Reality—Modern and Contemporary Women Artists from Turkey*,
 Istanbul Modern Museum, Istanbul, Turkey
 Where Fire Has Struck, DEPO Art Center, Istanbul, Turkey
2010 *Floating Volumes I*, Frise Art Gallery, Hamburg, Germany
 IDs Please!, CerModern, Ankara, Turkey
 Invisible Play, Independent Exhibition Space, Istanbul, Turkey
2009 *Istanbul Next Wave*, Akademie der Künste, Berlin, Germany
 Public Ideas, ECOC 2010/Muthesius Academy of Fine Arts and Design,
 Istanbul, Turkey, and Kiel, Germany
 Forschungsstationen, Kunstverein Langenhagen, Langenhagen, Germany
2008 *Dirty Movies*, Part of 54th International Short Film Festival Oberhausen,
 Oberhausen, Germany
2007 *Big Family Business*, Parallel Event, 10th Istanbul Biennial, Istanbul, Turkey
 Bad Luck Show, Marlan Gallery, Lexington, KY, USA
 Imagining the Book I, Bibliotheca Alexandrina, Alexandria, Egypt
 Too Much Freedom, 10th New Media Art Festival, The Hammer Museum,
 Los Angeles, CA, USA
 Coding: Decoding: Exhibition, The Museum of Contemporary Art, Copenhagen,
 Denmark
 Babel, Babble, Rabble, Other Gallery, Telus Studio, Banff Art Centre, Alberta,
 Canada
2005 *Cosmopolis I: 1st Balkan Biennial*, Thessaloniki Contemporary Art Museum,
 Thessaloniki, Greece
 Thinking Garbage, (project with Ipek Duben), Parallel Event 9th Istanbul
 International Biennial, Istanbul, Turkey
2002 *Look Again*, Proje 4L, Elgiz Contemporary Art Museum, Istanbul, Turkey
2001 *Re-Duchamp, Traveling Exhibition*, Parallel Event 7th International Istanbul
 Biennial, Istanbul, Turkey
 Voices From The Homeland, Karşı Art Works, Istanbul, Turkey
2000 *Young Art III*, Ankara Contemporary Art Center, Ankara, Turkey
 Local Products, Elhamra Gallery, Istanbul, Turkey
1999 *Between '99*, Istanbul Technical University, Istanbul, Turkey
1998 *Back-to-Back*, Arnavutköy Studio, Istanbul, Turkey
1997 *Between*, Ataturk Cultural Center, Istanbul, Turkey
1994 *Work*, STT, The Art Definition Group, Faruk Ilgaz Center, Istanbul, Turkey

Author Biographies

Nat Muller is an independent curator and critic. She has written numerous essays and catalog entries on art and politics and artists from the Middle East. Her writing has been published in *Bidoun, ArtAsiaPacific, Art Papers, Canvas, Art Margins, MetropolisM* and *Springerin,* among others. She is editorial correspondent for *Ibraaz.* With Alessandro Ludovico, she edited *Mag.net Reader2: Between Paper and Pixel* (2007), and *Mag.net Reader3: Processual Publishing, Actual Gestures* (2009), based on a series of debates organised at Documenta XII. She has taught at universities and academies in the Netherlands and the Middle East and has curated video and film screenings for projects and festivals internationally, including for *Rotterdam's International Film Festival, Norwegian Short Film Festival* and *Video D.U.M.B.O.* Recent curated projects include *Spectral Imprints* for the Abraaj Group Art Prize in Dubai (2012), Adel Abidin's solo exhibition *I love to love…* at Forum Box in Helsinki (2013), and *This is the Time: This is the Record of the Time* at Stedelijk Museum Bureau Amsterdam & American University of Beirut Gallery (2014/2015). In 2015, she was Associate Curator for the Delfina Foundation's Politics of Food Program in London.

Wendy M. K. Shaw (PhD UCLA, 1999) is Professor of the Art History of Islamic Cultures at the Free University of Berlin. She is the author of *Possessors and Possessed: Museums, Archaeology, and the Visualization of History in the Late Ottoman Empire* (University of California Press, 2003) and *Ottoman Painting: Reflections of Western Art from the Ottoman Empire to the Turkish Republic* (IB Tauris, 2012). Her work addresses the history and theory of institutions of art and visual culture at the intersections of cultural and gender identity.

Merve Ünsal is a visual artist based in Istanbul. In her works, she employs text and photography beyond their form. She holds an MFA in Photography and Related Media from Parsons The New School of Design and a BA in Art and Archaeology from Princeton University. She was a participant at the Homework Space Program 2014–2015 at Ashkal Alwan, Beirut, and has participated in artist residencies at the Delfina Foundation in London and at the Banff Centre in Alberta. She is the founding editor of the artist-driven online publishing initiative m-est.org.

Acknowledgements

The artist thanks Volkan Aslan, Dilek Aydın, Betül Aytaç, Ahmet Esmen, Tolga Şinoforoğlu, Maria Andersson and the team at Pi Artworks Istanbul London, in particular Yeşim Turanlı. She expresses her sincere appreciation to her dear husband, two sons, and two daughters-in-law for their generosity and support throughout this journey.

© 2016 Kehrer Verlag Heidelberg Berlin, Nancy Atakan and authors

Editor: Nat Muller
Texts: Nat Muller, Wendy Shaw, Yeşim Turanlı and Merve Ünsal
Copyediting: Nat Muller
Proofreading: Anthony Santoro
Design: Kehrer Design Heidelberg (Katharina Stumpf)
Image processing: Kehrer Design Heidelberg (Patrick Horn)
Production: Kehrer Design Heidelberg (Andreas Schubert)

Printed and bound in Germany
ISBN 978-3-86828-643-4

 Kehrer Heidelberg Berlin
www.kehrerverlag.com